Autumn 2015 Art

Art Auction

By
SHAN PECK

Copyright © 2015 Shan Peck

All rights reserved.

ISBN-13: 978-1519459220

Dedication

For all people that love art.

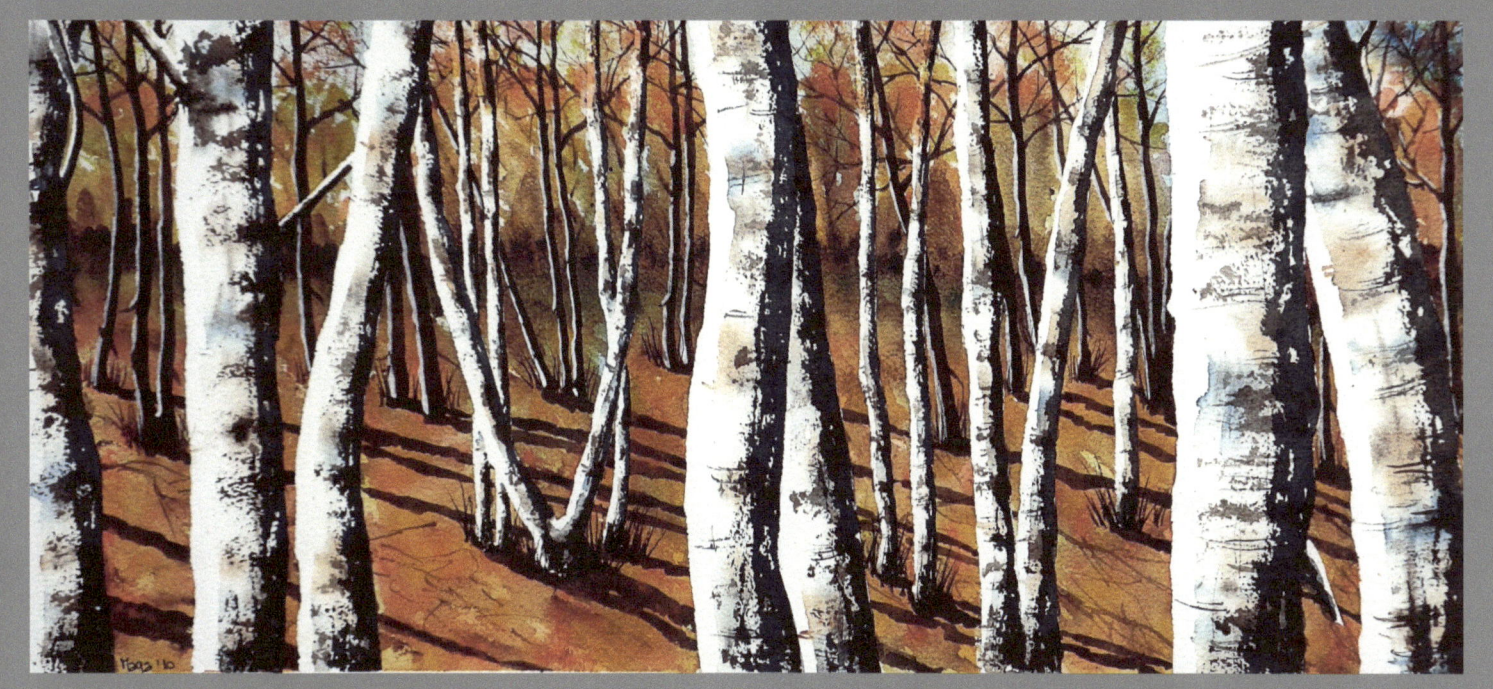

THE SENTINELS 3- ART BY MARISA GABETTA
21.300 X 9.400 INCHES
$200.00

maga7960@yahoo.it

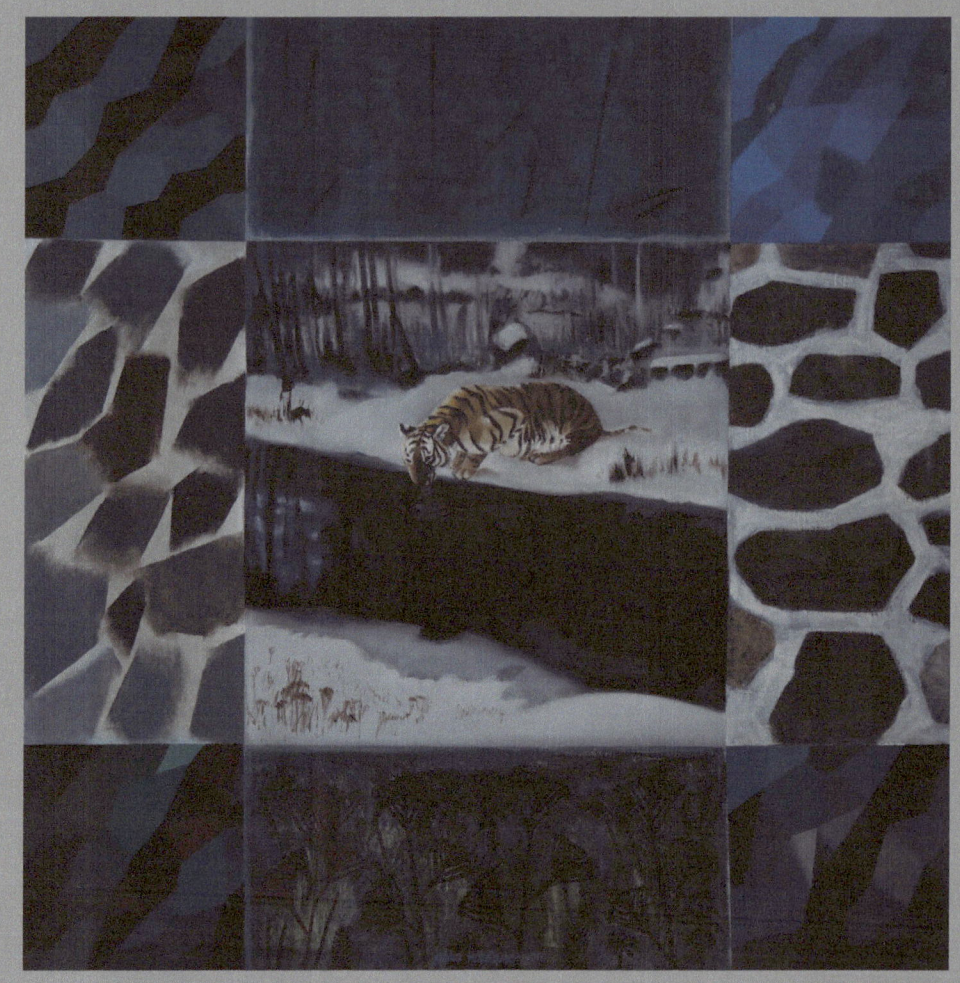

FAR FROM HOME - ART BY JUKKA NOPSANEN
110 X 110 CENTIMETERS
$6,000.00
jukka.nopsanen@kolumbus.fi

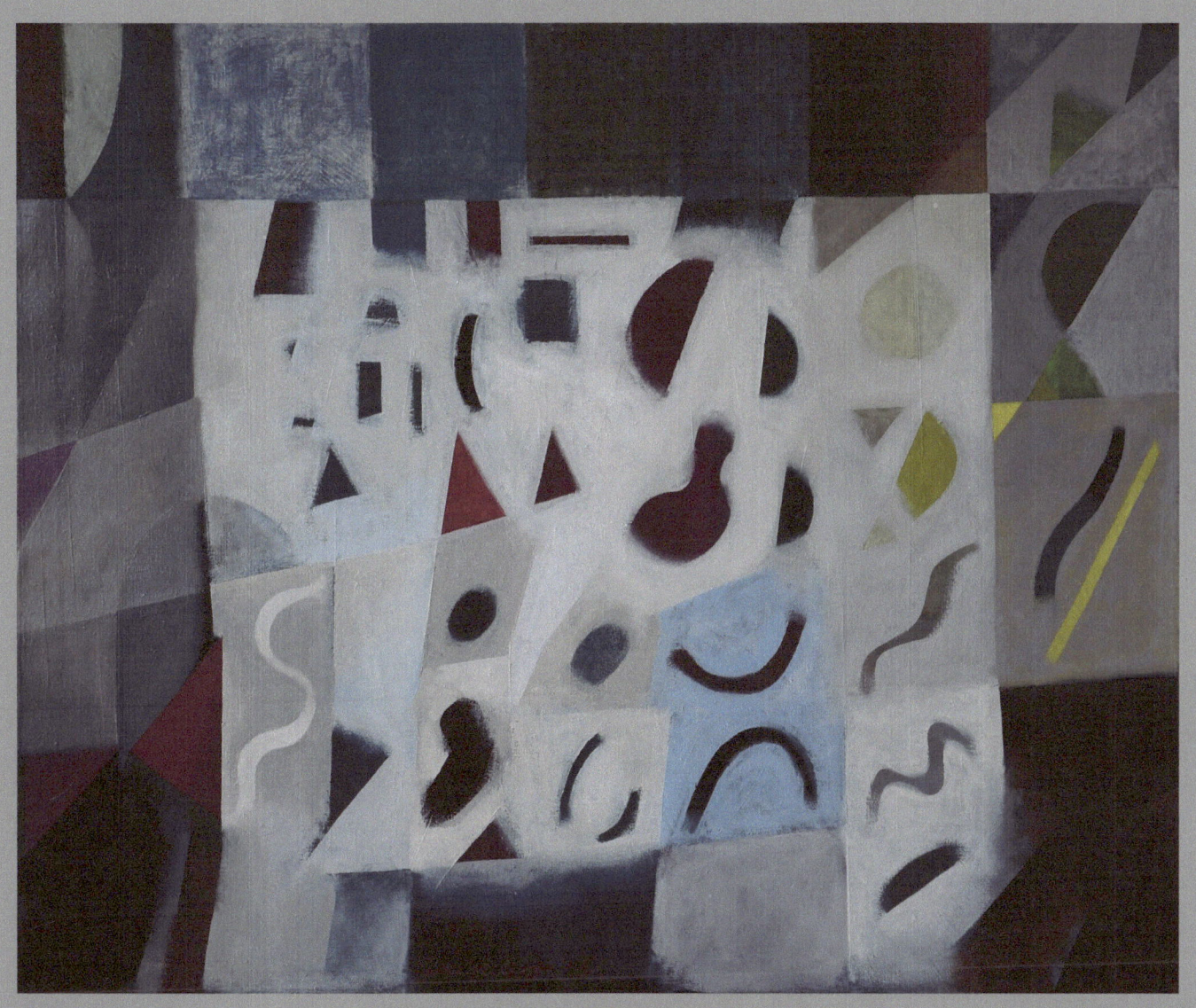

ENIGMA - ART BY JUKKA NOPSANEN
81 X 100 CENTIMETERS
$6,000.00
jukka.nopsanen@kolumbus.fi

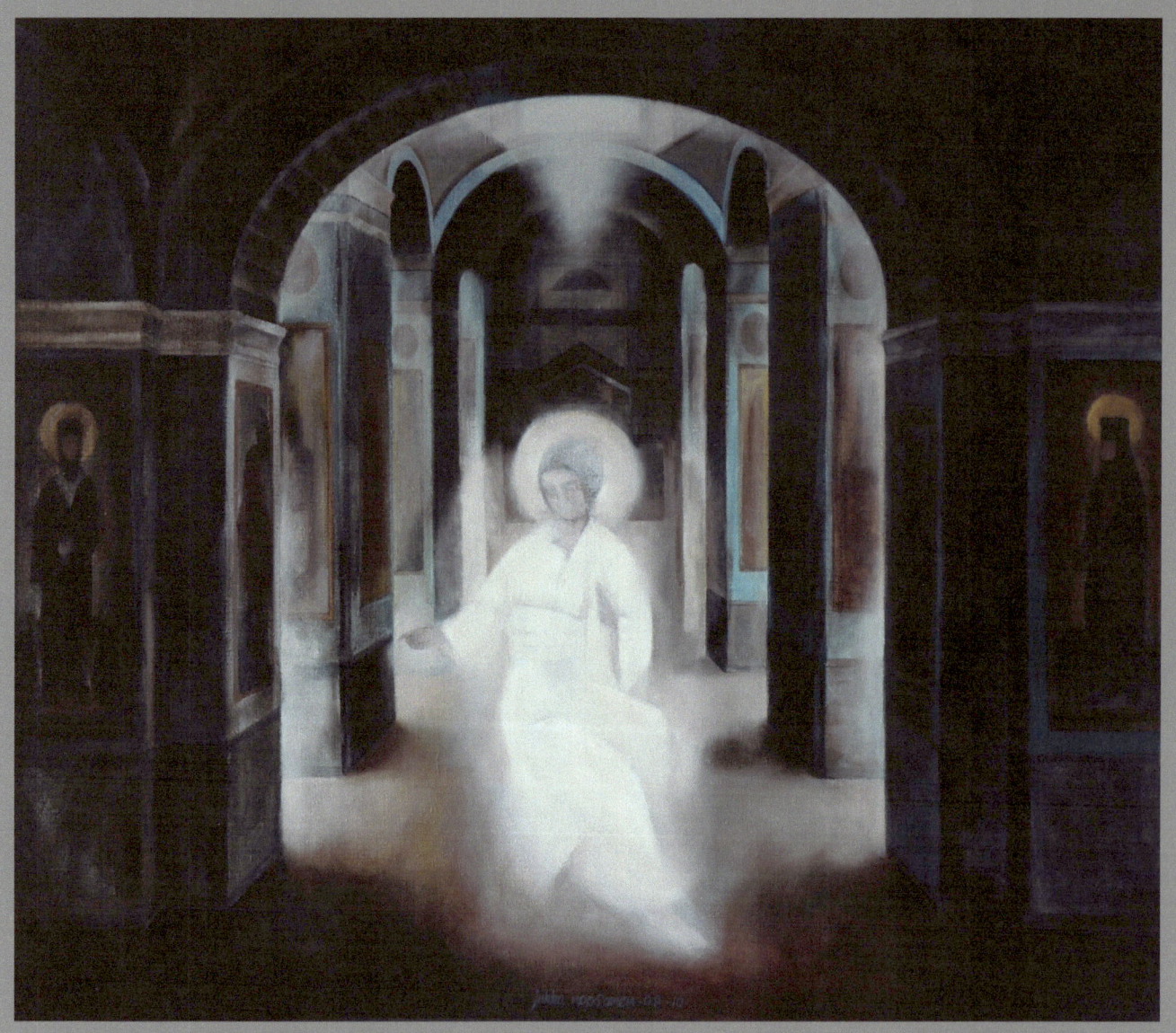

RELEVATION - ART BY JUKKA NOPSANEN
100 X 120 CENTIMETERS
$7,000.00
jukka.nopsanen@kolumbus.fi

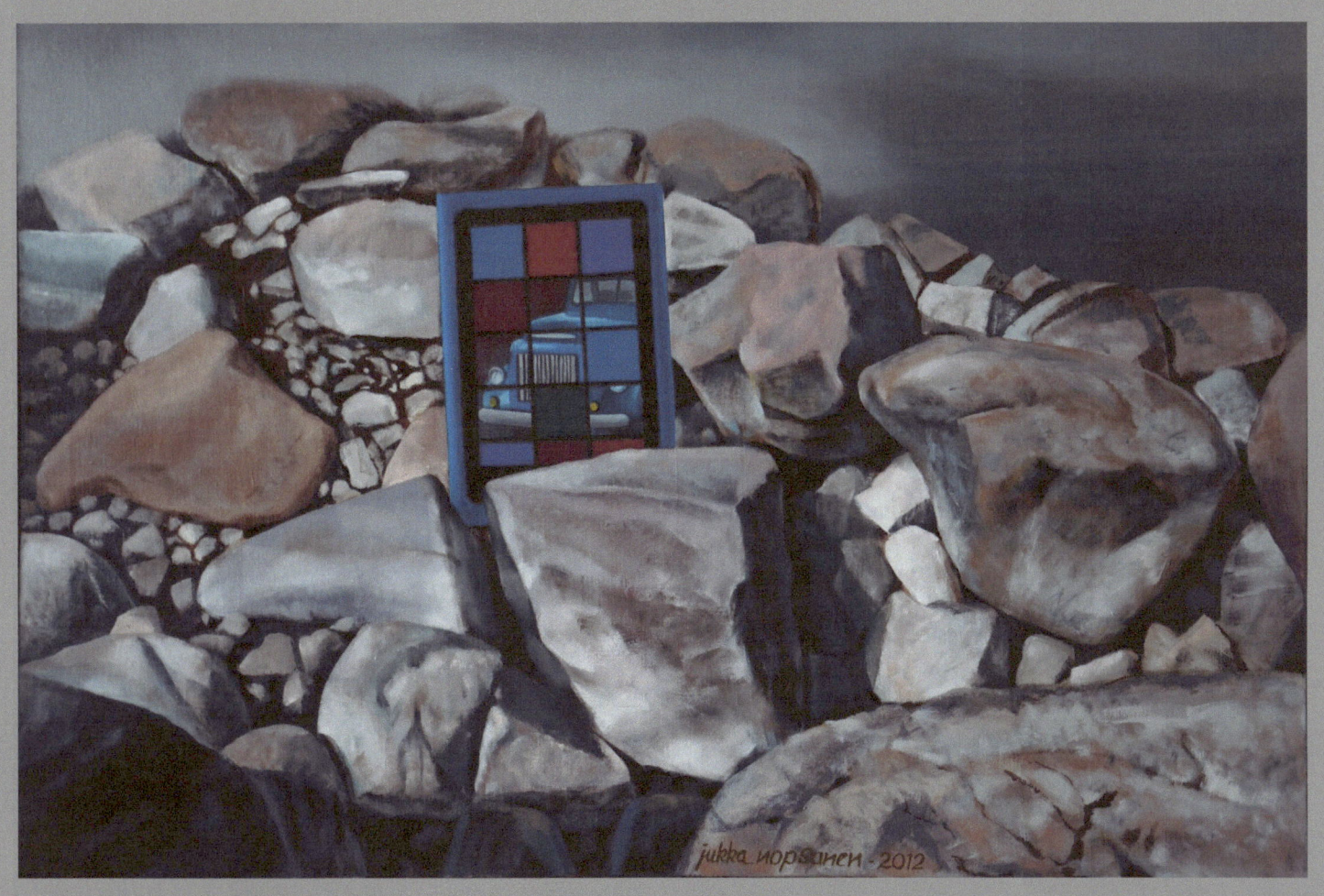

THE ICON OF TODAY - ART BY
JUKKA NOPSANEN
65 X 100 CENTIMETERS
$5,000.00

jukka.nopsanen@kolumbus.fi

DEVASTATION - ART BY JUKKA NOPSANEN
150 X 80 CENTIMETERS
$7,000.00
jukka.nopsanen@kolumbus.fi

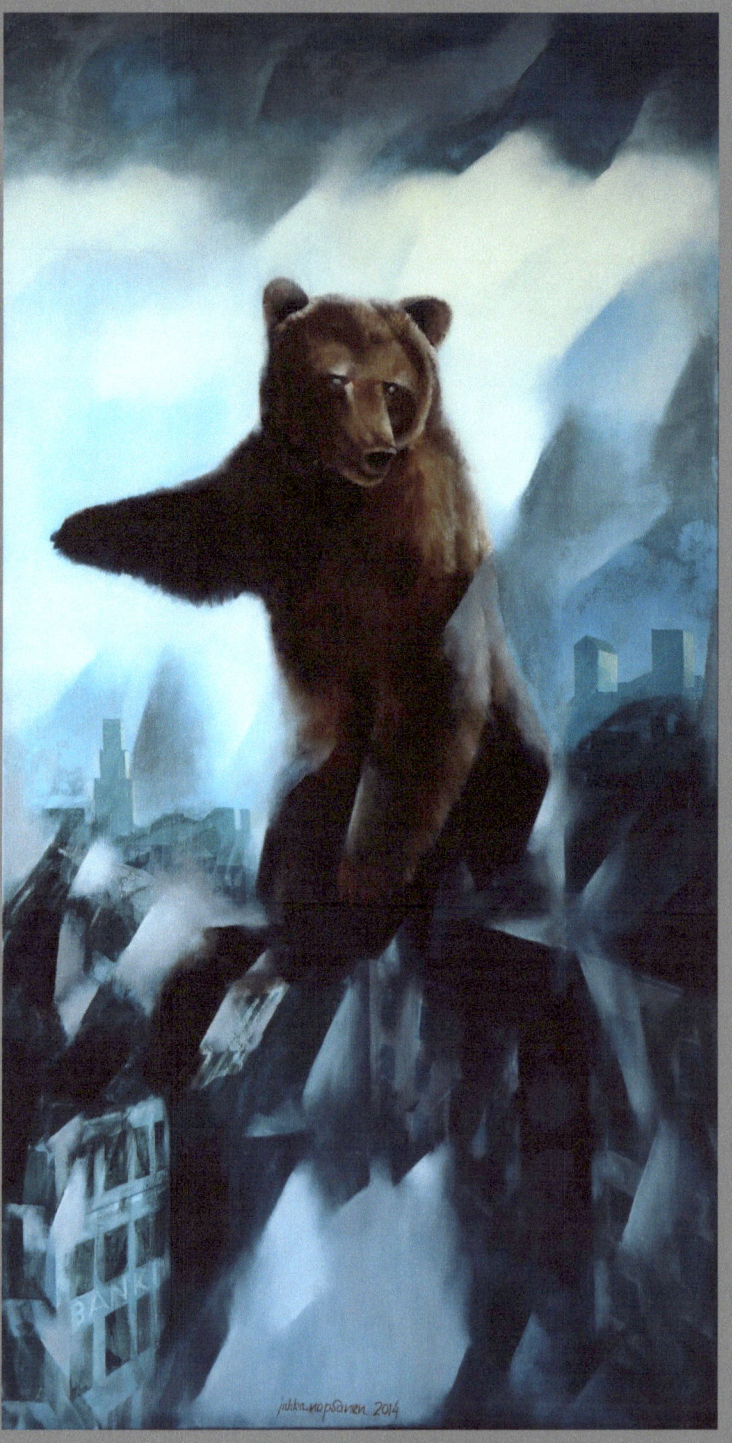

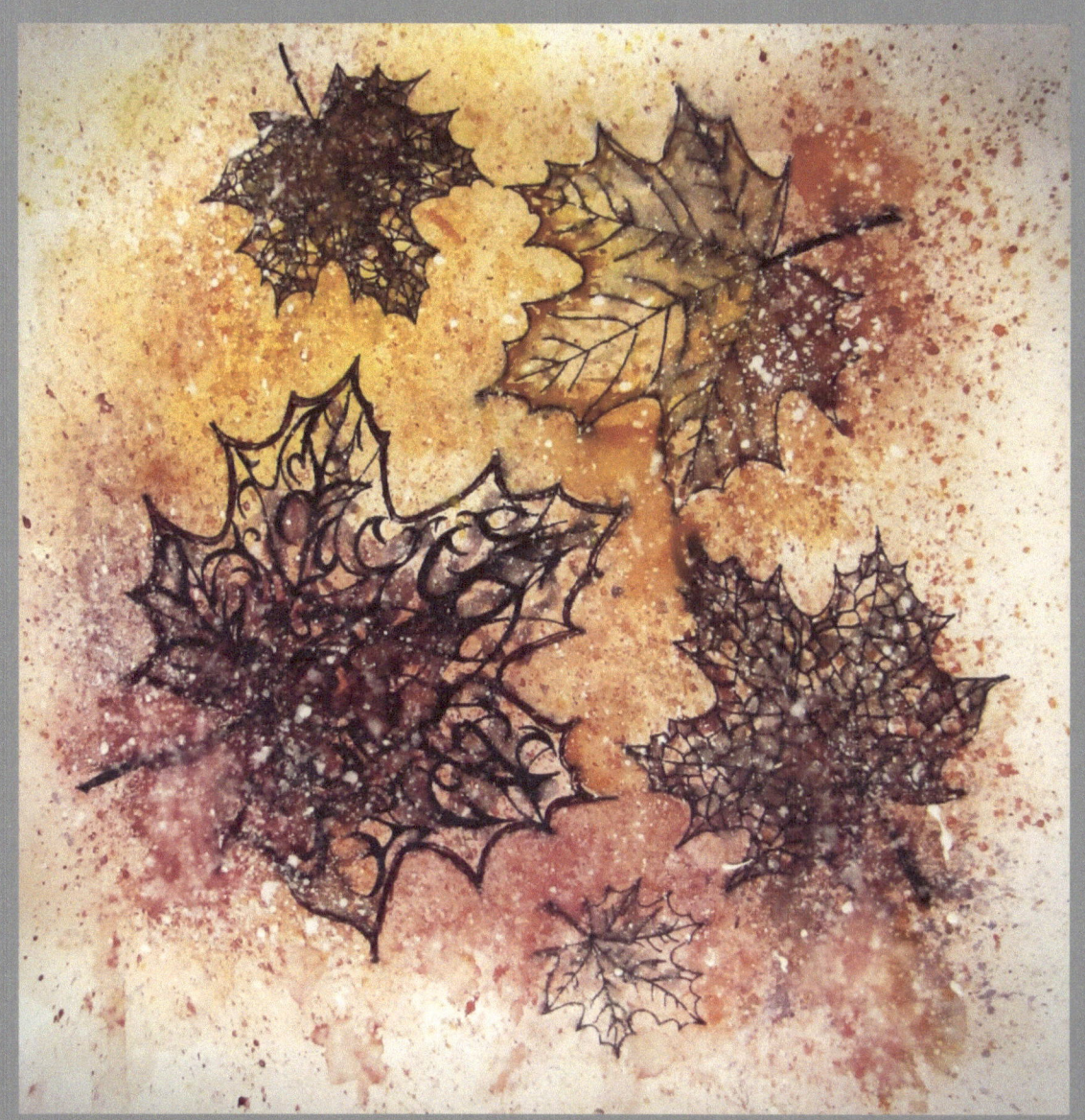

AUTUMN LEAVES / BRIGHTNESS OF FALL – ART BY RERA KRYZHNAYA
11.7 X 11.7 INCHES
$ 50.00

kryzhnaya@gmail.com

SOLITUDE – ART BY RERA KRYZHNAYA
11.7 X 16.5 INCHES
SOLD

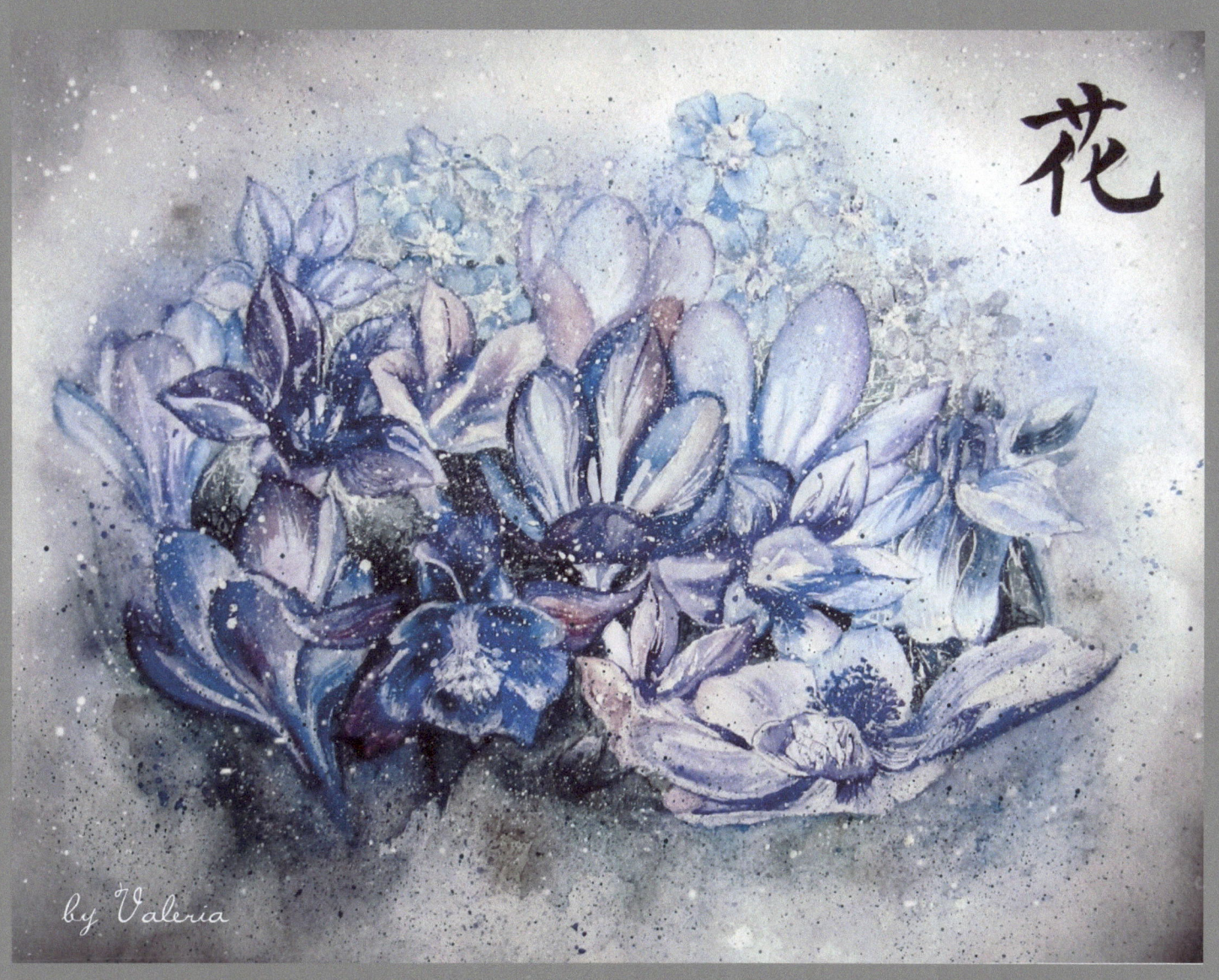

HANA / FLOWERS – ART BY RERA KRYZHNAYA
16.5 X 11.7 INCHES
$300.00
kryzhnaya@gmail.com

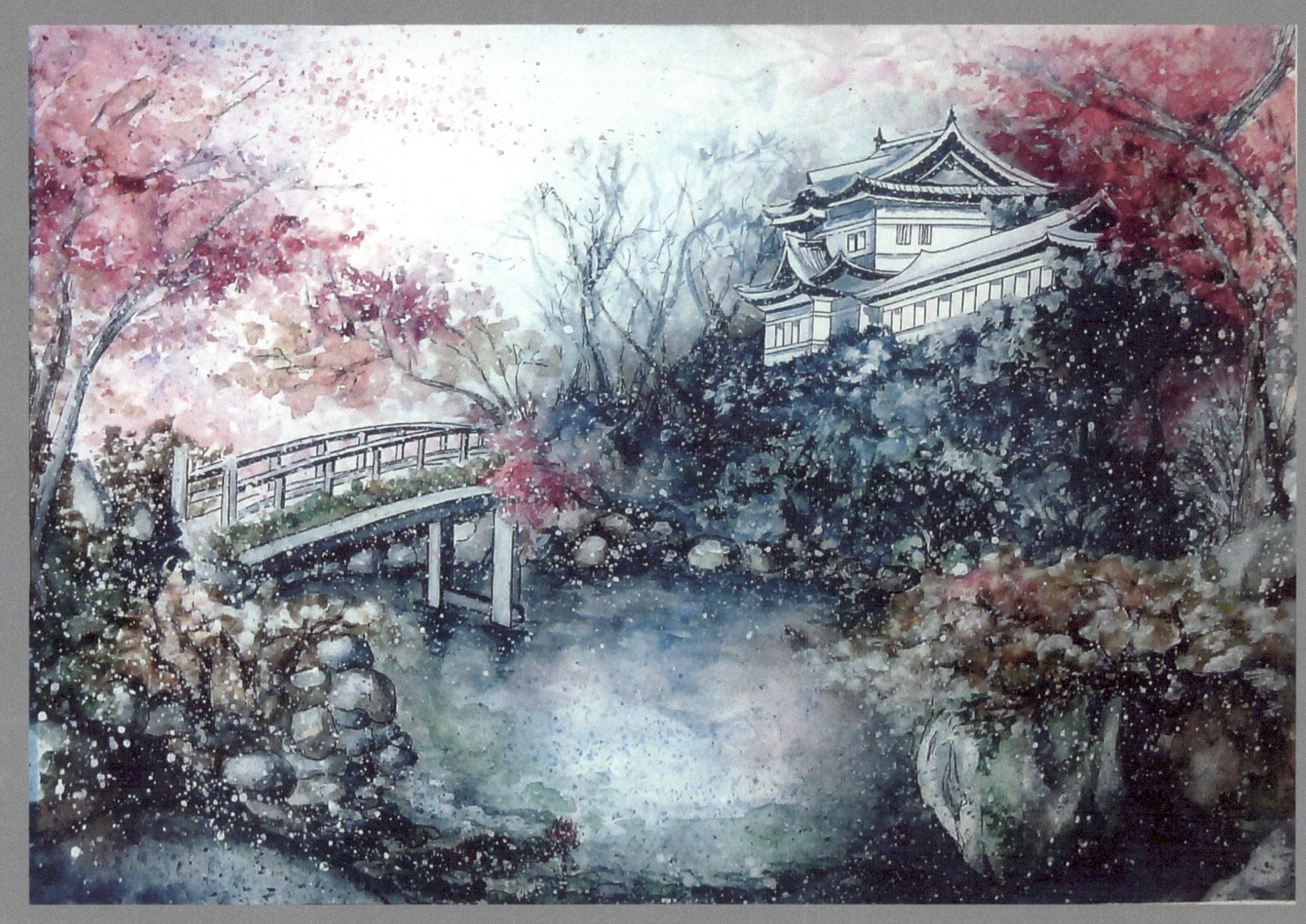

MOMIJI / SEASON OF RED MAPLE LEAVES
– ART BY RERA KRYZHNAYA
16.5 X 11.7 INCHES
SOLD

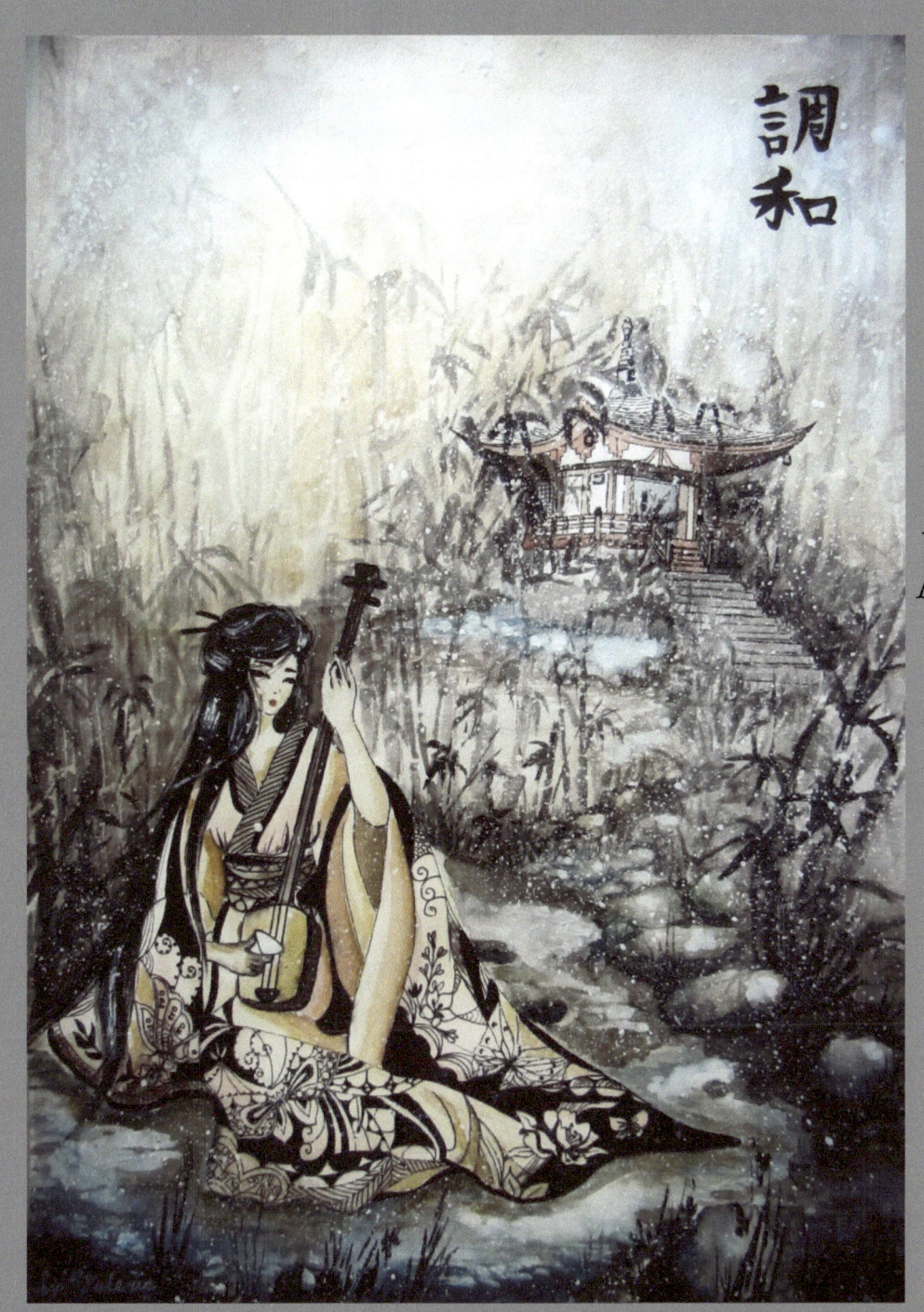

AUTUMN CREEK / AKI NO OGAWA – ART BY RERA KRYZHNAYA
11.7 X 16.5 INCHES
SOLD

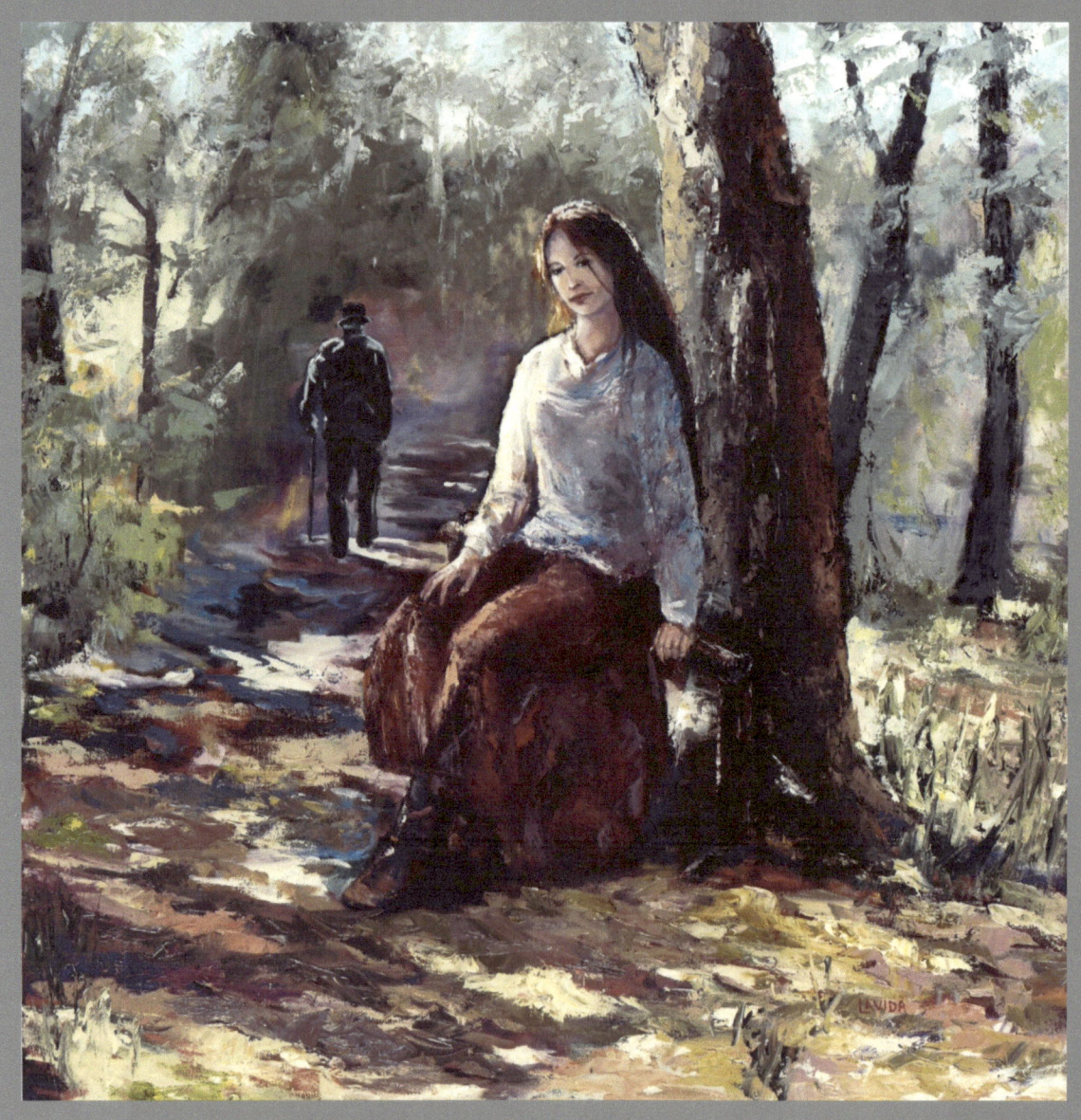

A QUIET SEASON – ART BY JANET LAVIDA
30.0 X 30.0 INCHES
$7000.00
jlavida@aol.com

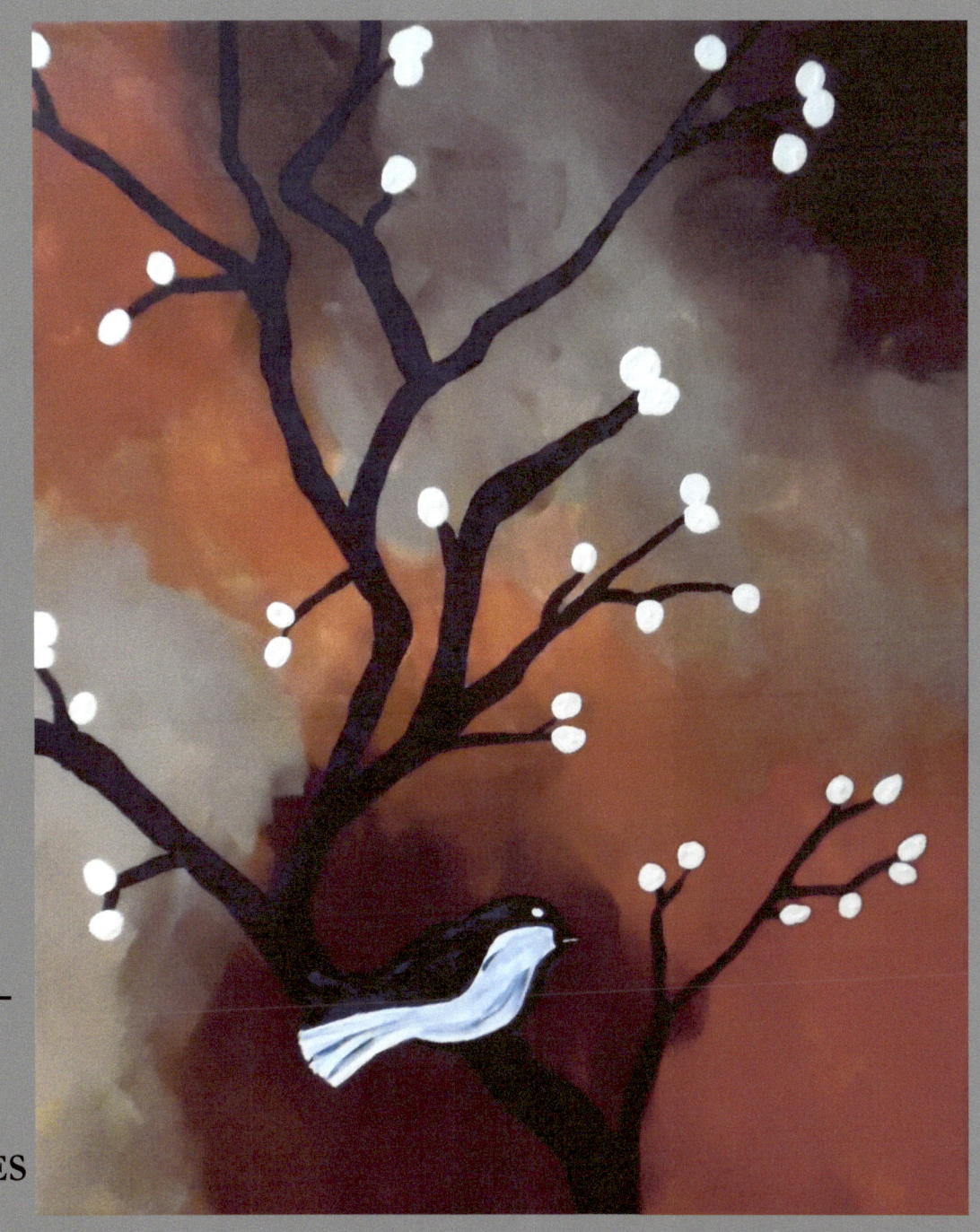

COTTON SPICE – ART BY JILIAN CRAMB

16.0 X 20.0 INCHES
$142.00

asherjacobsmommy@gmail.com

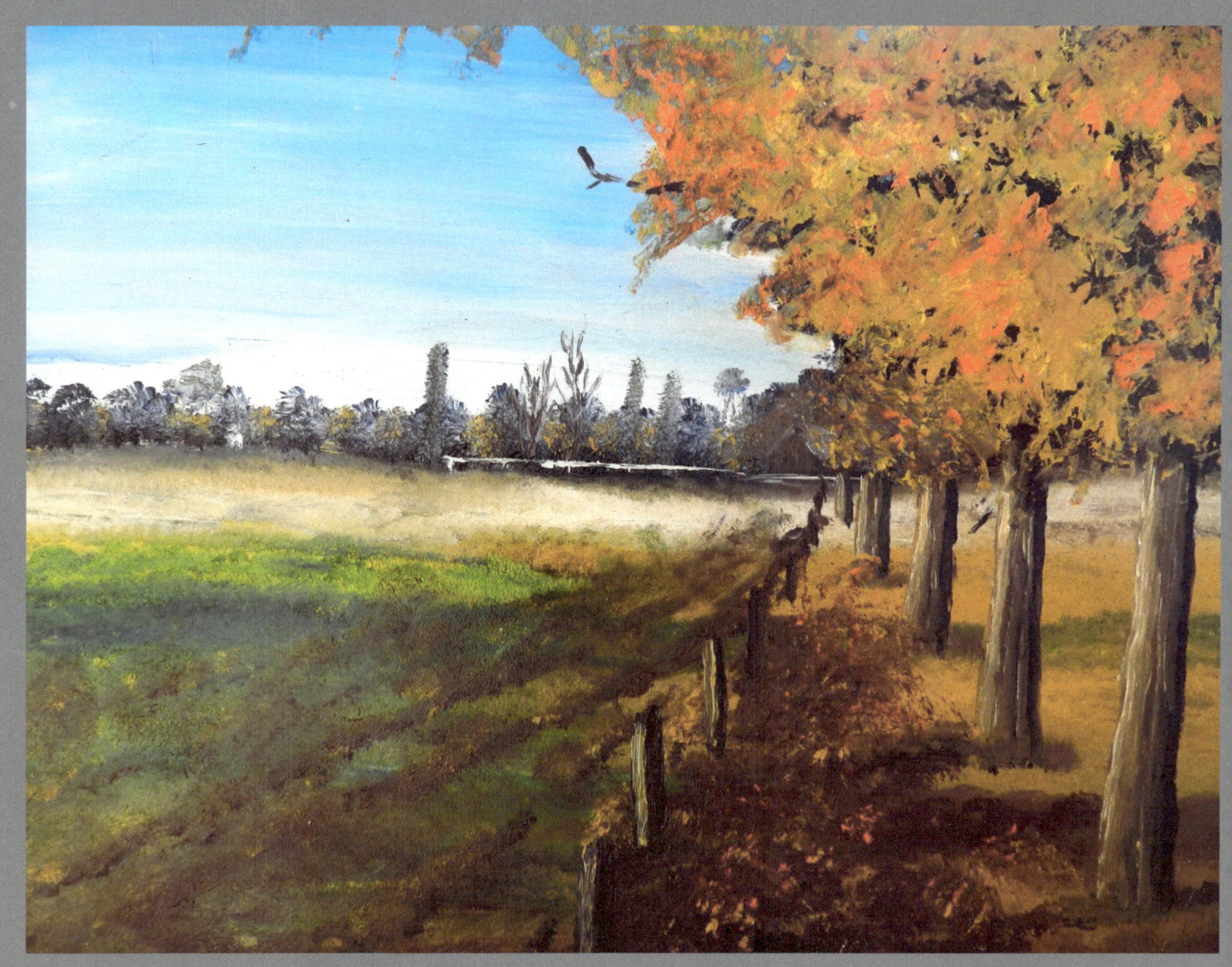

CAMDEN FAR – ART BY PAMELA MEREDITH
35.5 X 46 CENTIMETERS
$360.00
pmeredith6@bigpond.com

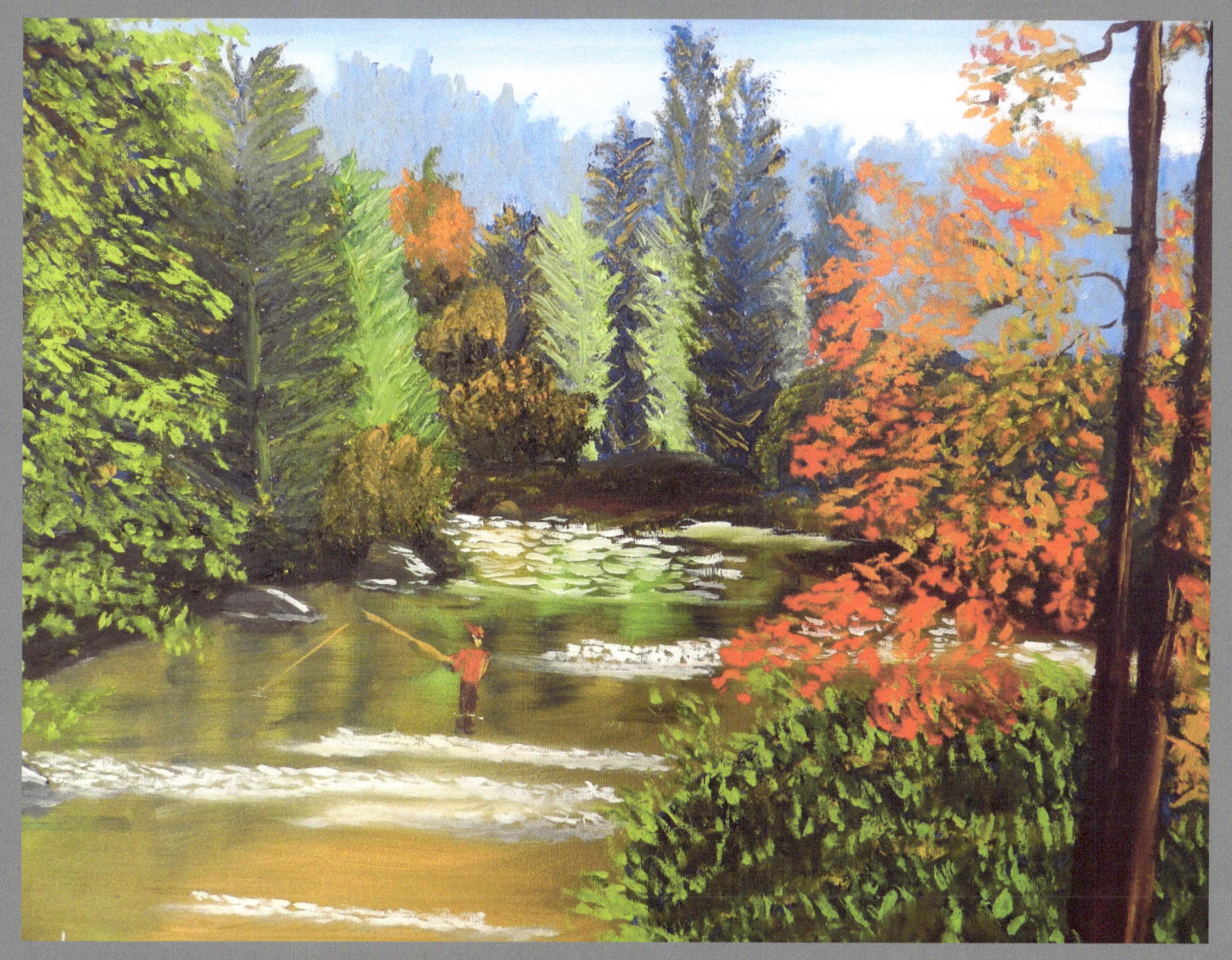

MOUNTAIN STREAM – ART BY PAMELA MEREDITH
40 X 50 CENTIMETERS
$360.00
pmeredith6@bigpond.com

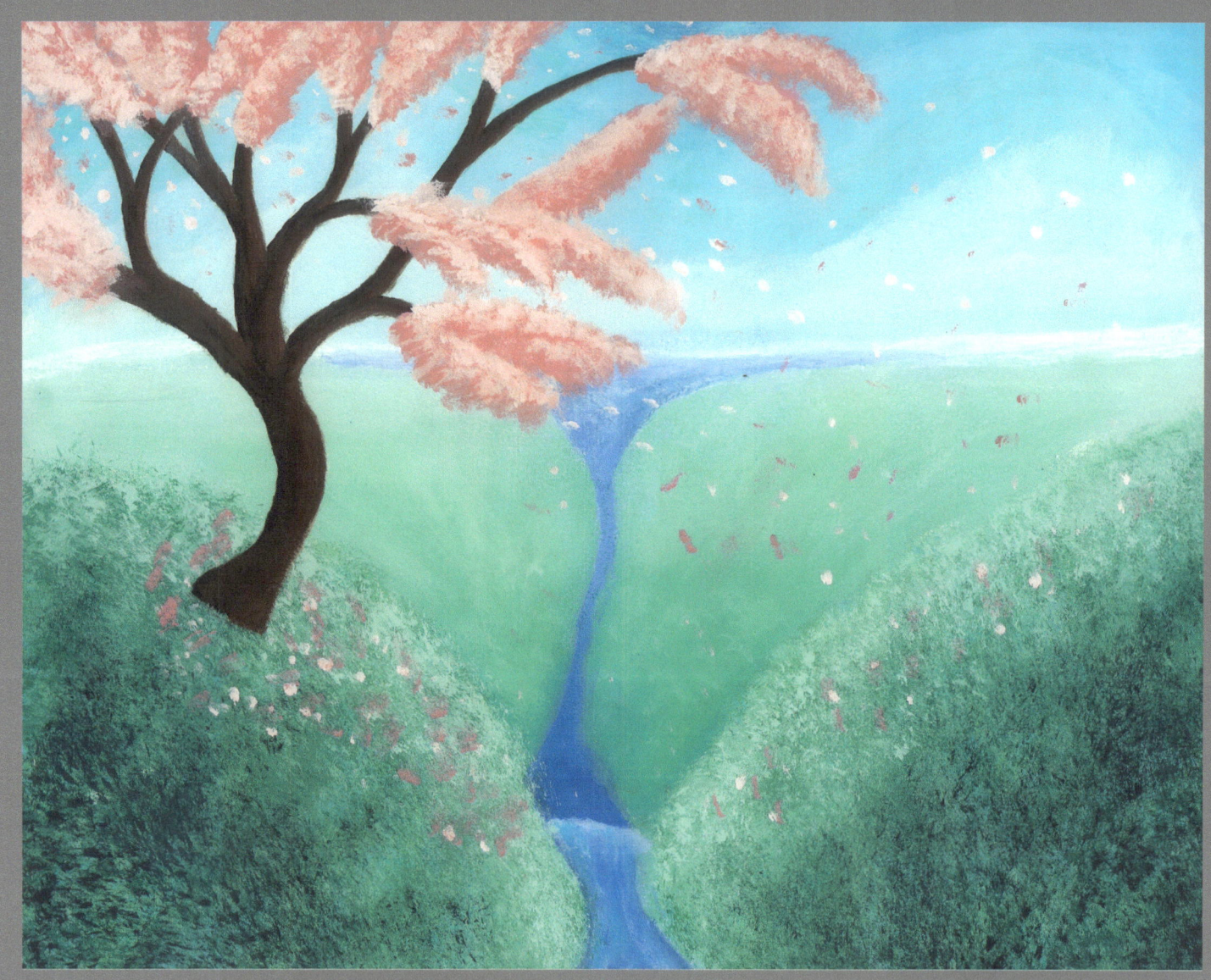

**THE FINER THINGS IN LIFE – ART BY
CALEB GROW
14 X 11 INCHES
NOT FOR SALE**

cgrow88@yahoo.com

WEATHERED DOOR RUSTIC PATH – ART BY MICK WILLIAMS
14.5 X 21.5 INCHES
$ 850.00

fineartbymick@gmail.com

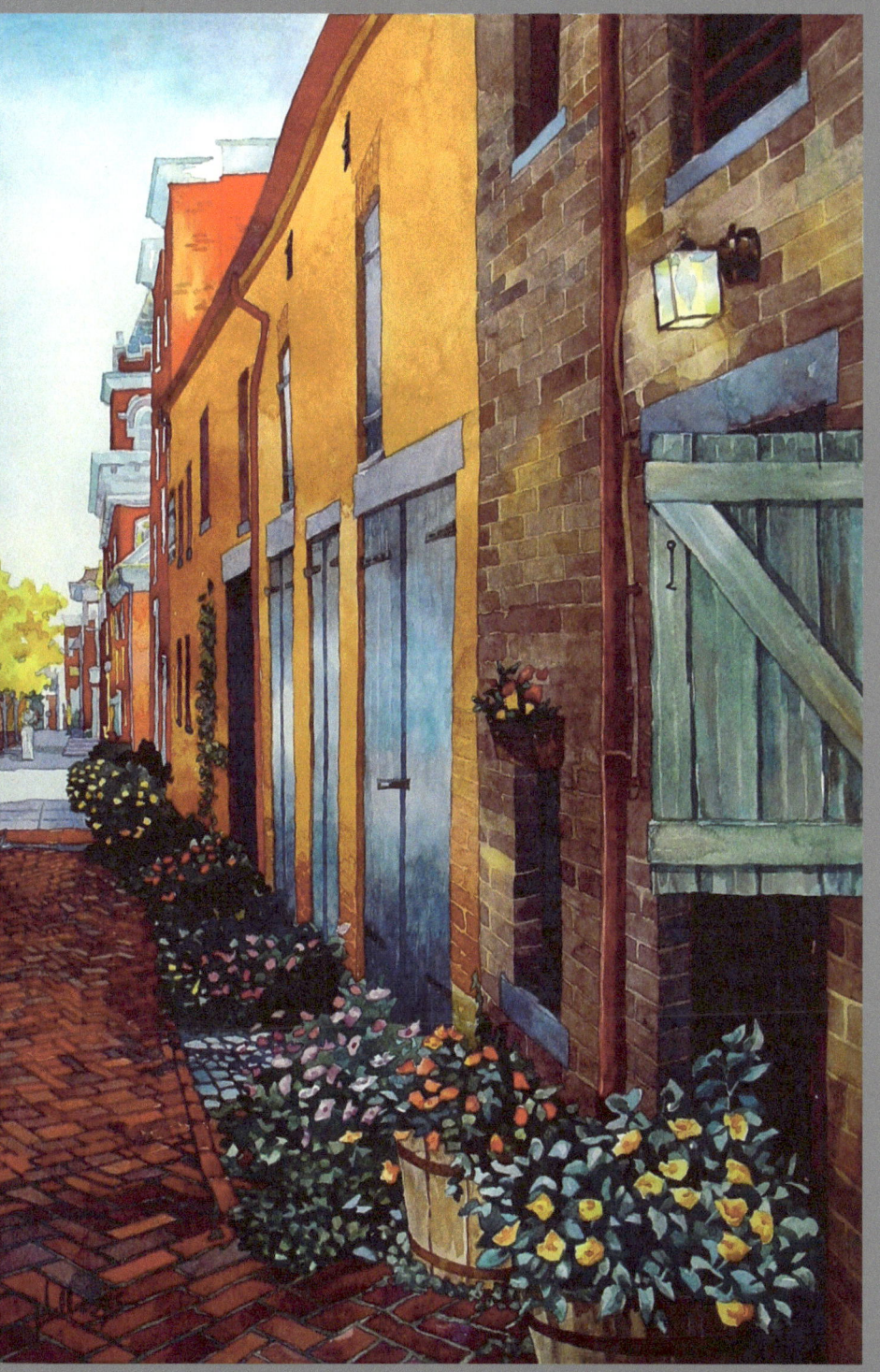

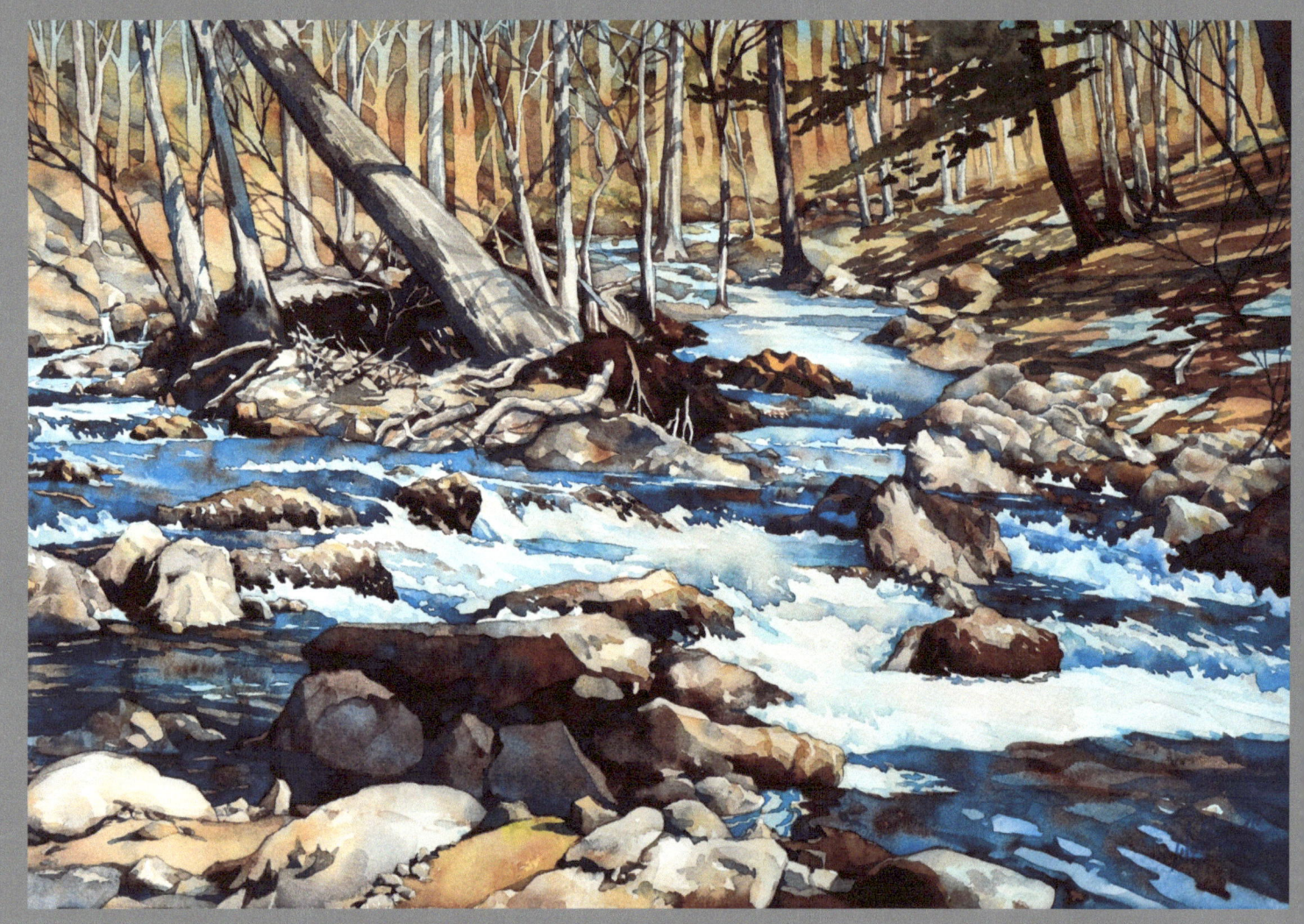

SPRING THAW – ART BY MICK WILLIAMS
22 X 15 INCHES
$ 850.00
fineartbymick@gmail.com

THE LONG WALK TO
MARKET – ART BY
MICK WILLIAMS
14.5 X 21.5 INCHES
$ 850.00 - SOLD

fineartbymick@gmail.com

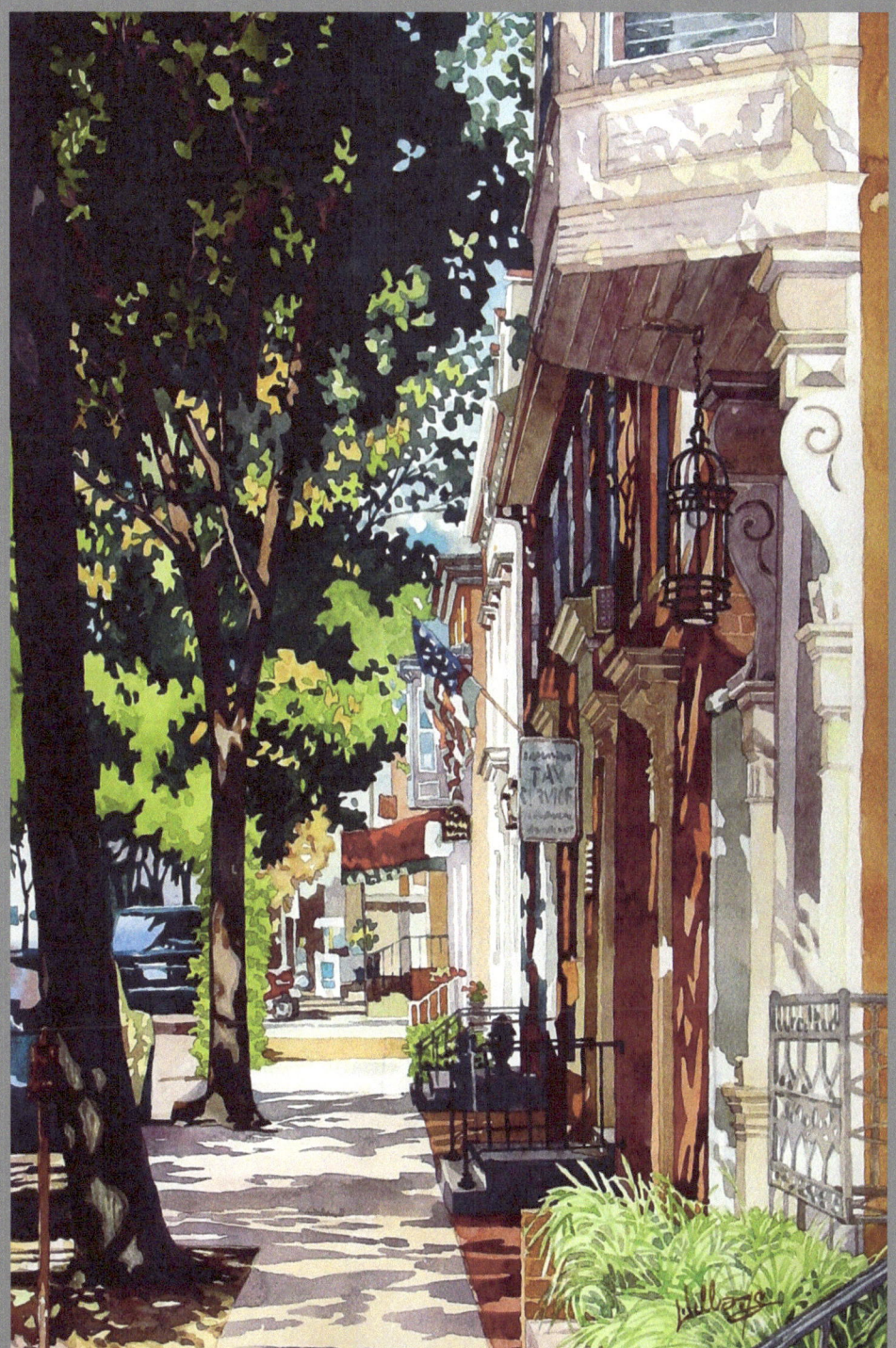

STRAW HAT – ART
BY IRINA STROUP
12 X 14 INCHES
$ 300.00 - SOLD

iragrit@hotmail.com

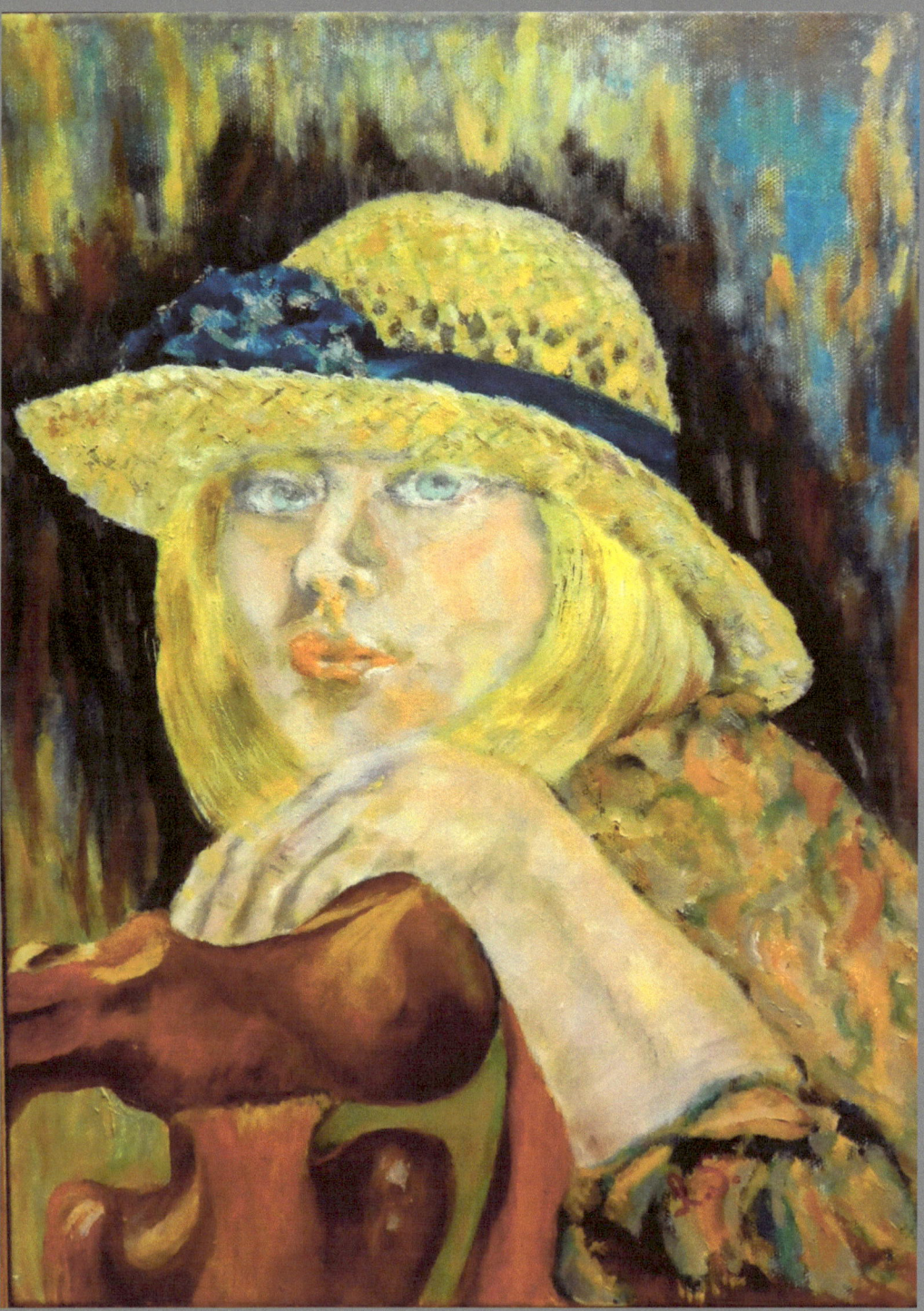

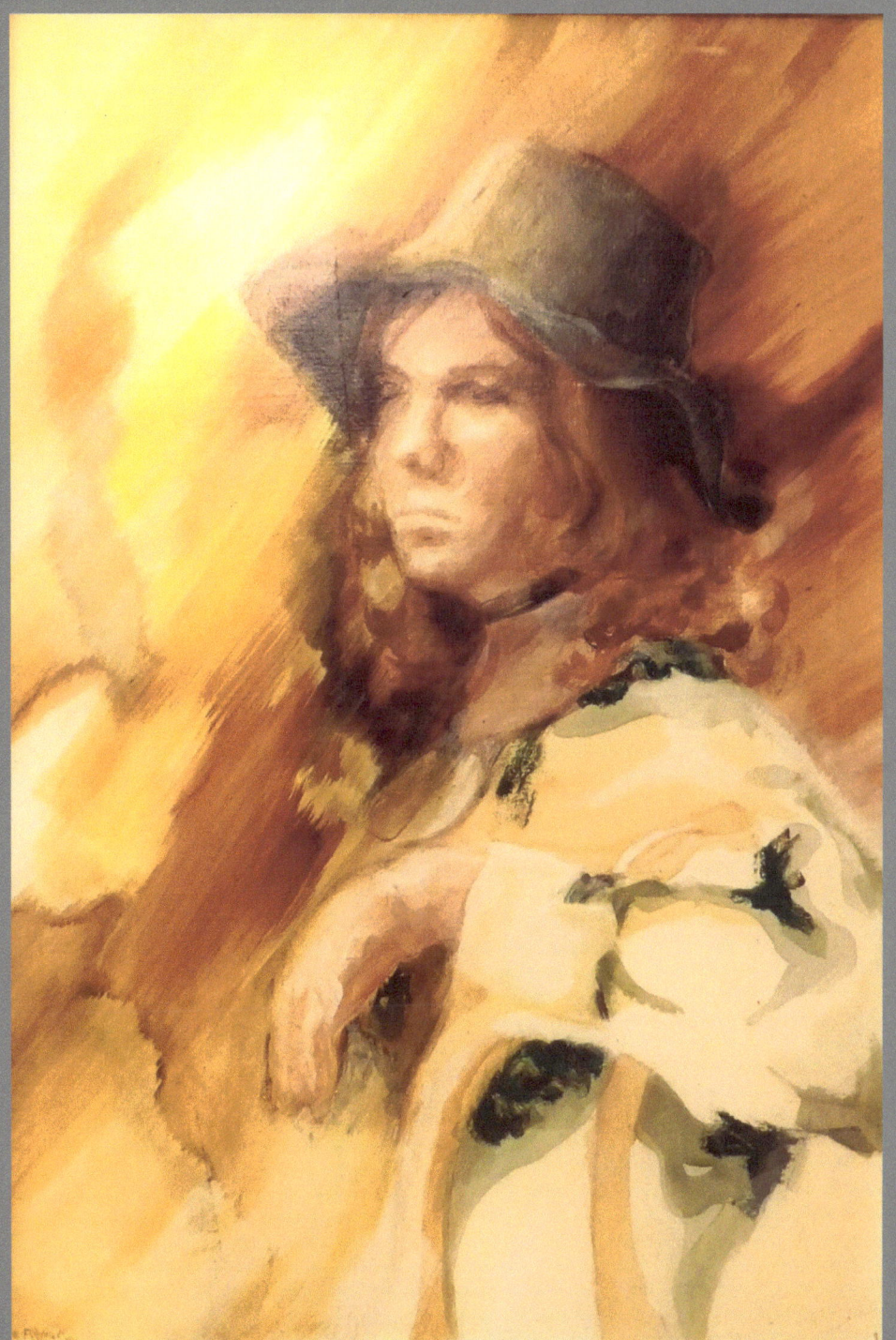

TANGY – ART BY
DENISE FULMER
22 X 30 INCHES
$ 150.00
dffladybug@gmail.com

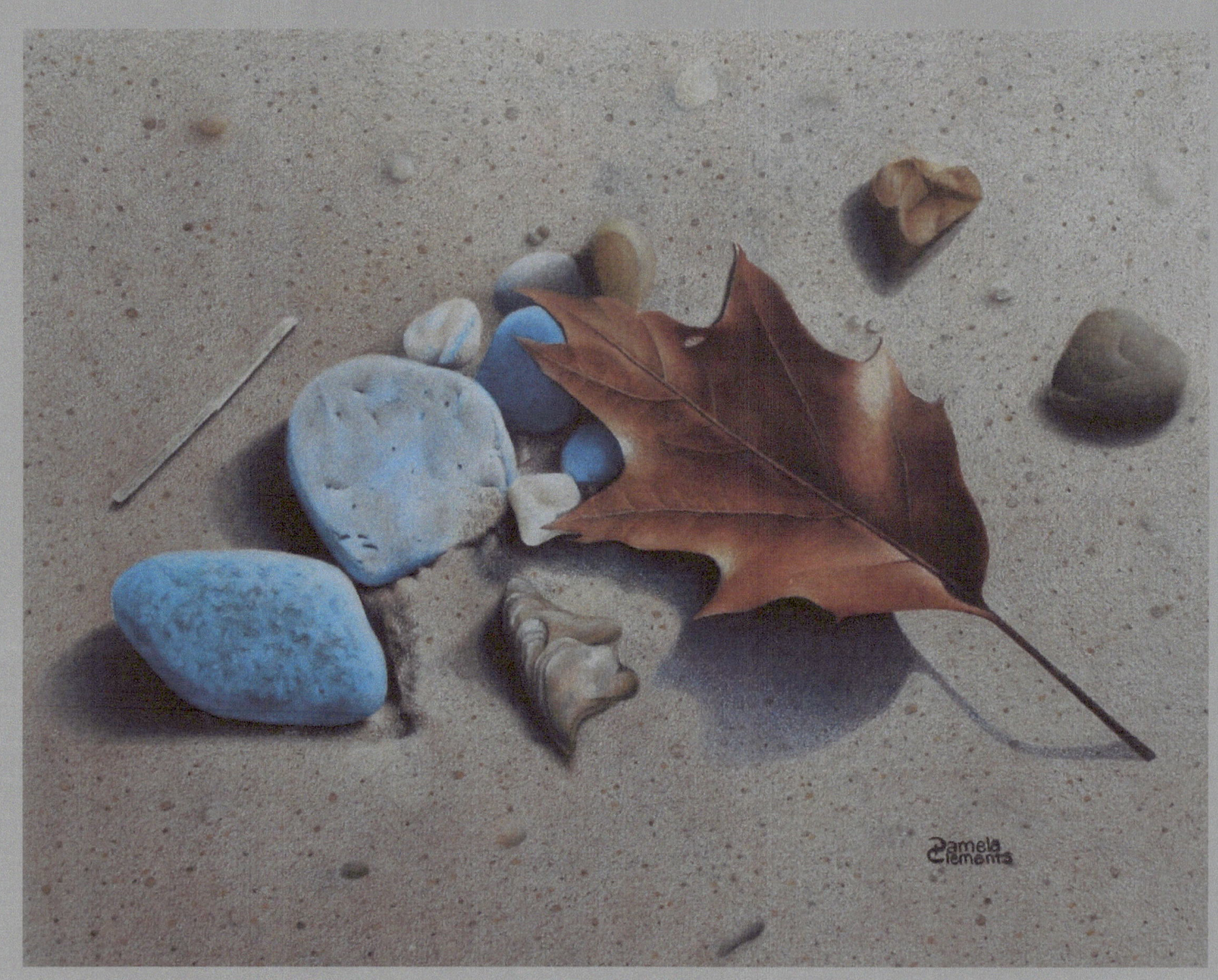

BEACH STILL LIFE II – ART BY PAMELA CLEMENTS
11.75 X 8.75 INCHES
$ 500.00
pamela.clements@sbcglobal.net

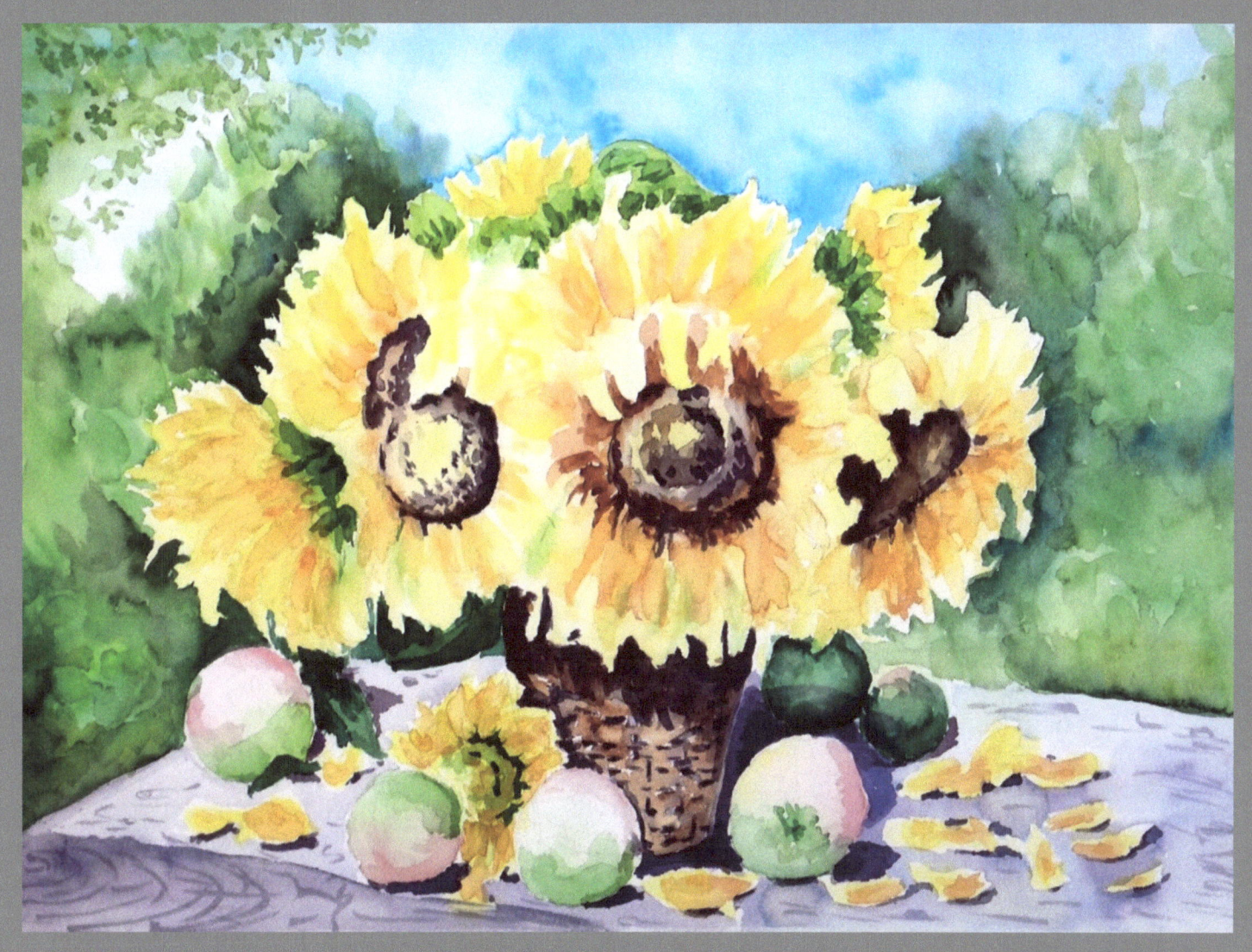

JUDERIA SEVILLA – ART BY LIDIA ESSEN
10.5 X 16.5 INCHES
$ 50.00

lessen@list.ru

WALK IN THE
LIGHT OF YOUR
PRESENCE –
ART BY GARY
SLUZEWSKI
15 X 12 INCHES
$ 650.00

gary@garysluzewski.com

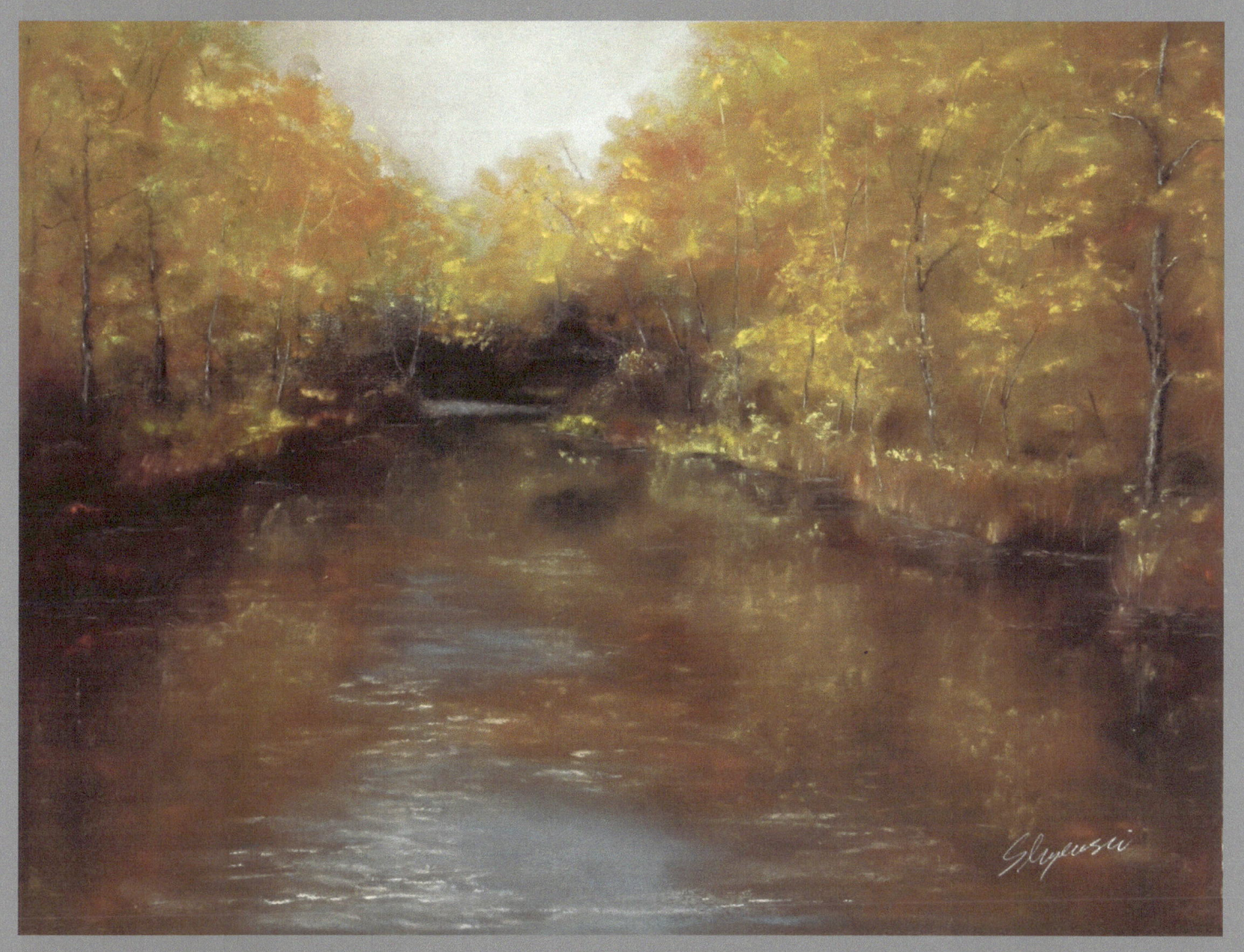

REFLECTIONS – ART BY GARY SLUZEWSKI
12 X 16 INCHES
$ 850.00
gary@garysluzewski.com

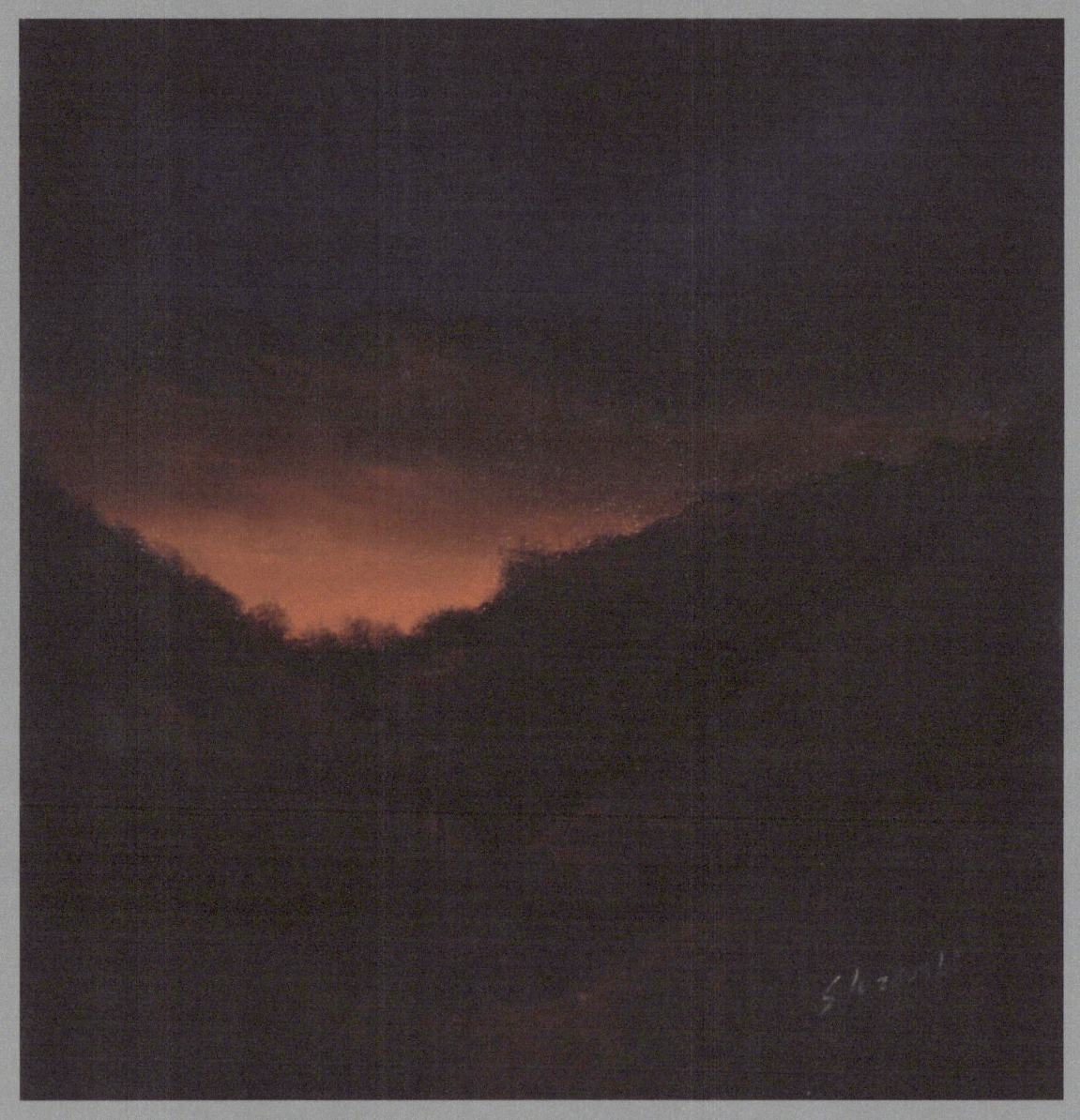

SUNDOWN – ART BY GARY SLUZEWSKI
9.5 X 9.5 INCHES
$ 450.00
gary@garysluzewski.com

ABOUT THE AUTHOR

At the age of 15, he started to write short stories, poems, screen plays. When 19 of age, worked as technician at the film studios, department for special effects and light. Worked also on movie Amadeus, directed by Oscar winning director, Milos Forman. At age 24, emigrated to United States. In 1989 moved to California where he joined theatre group Gilbert & Sullivan. During his stay in California went to Santa Barbara Community College where he visited several accredited courses as Business law and Design. After death of his father in 2001, he returned to his birth country where he worked as Quality Engineer, Quality Assurance manager and Manufacturing Project Manager. In quality assurance he got Black Belt / 6 Sigma training while working in automotive industry.

He had few art shows in Europe and United States. On top of fine art painting, he also started to do sculptures and the other strong activity that he spent a lot of time with – design inventions, technical and design improvements in fields like optics, acoustics and motion picture E^2E^2 systems. Currently he writes his second book which is also written in parallel, as screen play for the film.

E MAIL CONTACT: motyl_1999@yahoo.com